T0096603

# EVESHAM
## HISTORY TOUR

*To Peter ('Kipper') Lippett*

First published 2022

Amberley Publishing
The Hill, Stroud,
Gloucestershire, GL5 4EP
www.amberley-books.com

Copyright © Stan Brotherton, 2022
Map contains Ordnance Survey data
© Crown copyright and database
right [2022]

The right of Stan Brotherton to be
identified as the Author of this work
has been asserted in accordance with
the Copyrights, Designs and Patents
Act 1988.

ISBN  978 1 3981 0257 6 (print)
ISBN  978 1 3981 0258 3 (ebook)

British Library Cataloguing in
Publication Data.
A catalogue record for this book is
available from the British Library.

Origination by Amberley Publishing.
Printed in Great Britain.

# ACKNOWLEDGEMENTS

Many thanks to the Vale of Evesham Historical Society (VEHS) for permission to use images from their excellent collections. Thanks to Merry Privett for permission to use one of her photographs. Thanks to Angela Byrd Barrett for sharing material on the Bengeworth Observatory.

Thanks to the Churches Conservation Trust for permission to use images of the interior of St Lawrence's Church, to Revd Mark Binney for permission to use photos of the interior of St Andrew's Church, Hampton, and to Revd Andrew Spurr for permission to use photos of the interior of All Saints.

# INTRODUCTION

This book describes a meandering walk through the picturesque market town of Evesham. It's not quite a circular tour (being more of a raggedy scribble) but it starts and ends at the town's ancient sacred centre (in Abbey Park).

When walking around an old town like Evesham, it pays to spend some time looking up, looking down, and looking around. There are all sorts of curious features tucked away in unconsidered corners. Underneath your feet you will find a wide range of paving. In the churchyard there are cobblestones (hiding an old burial road?). In Vine Street and High Street there are history slabs and the pointers for the Battlefield Trail. If you look at the rooflines you will sometimes see evidence of antiquity. In Vine Street and Waterside, for example, there are curiously crooked medieval roofs sometimes on buildings that appear much newer.

This is a walk through space and time, through geography and history, plus a little bit of legend. Like every English town, Evesham is a curious mix of historical continuity and modern development. There are also special places where there is now nothing, but where something once stood – most famously, for Evesham, the site of the abbey. The centre of the town is shaped around the 'imposing absence' of Evesham Abbey. Perhaps most surprisingly, in the heart of town there is a large green space – a truly extraordinary feature. The tour described here is a walk around that big green heart.

Inevitably with a history walk, you will find yourself pondering how the past has shaped the present, and how the present evokes and points to the past. Perhaps inevitably this will beg the question: what about the future?

# KEY

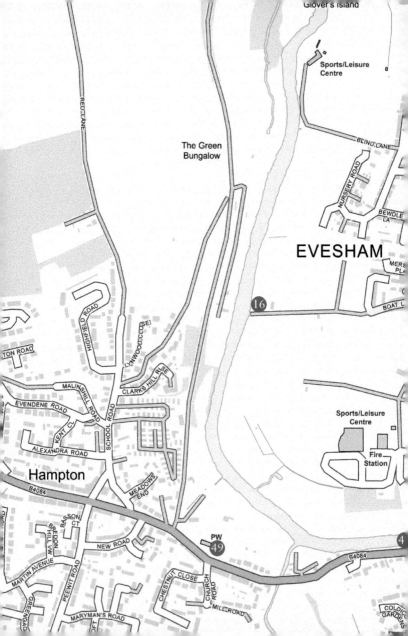

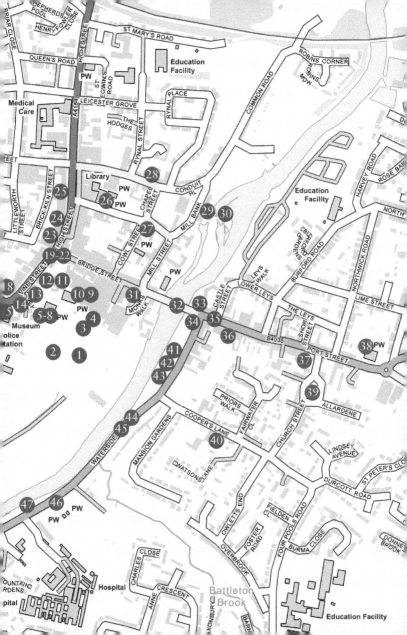

# 1. ABBEY PARK

The story of Evesham starts with the Anglo-Saxon foundation of Evesham Abbey (*c.* 709) by St Ecgwin. The spur for founding the abbey was a vision of the Virgin Mary, making it the first of two such Marian-inspired foundations in England (the other is Walsingham). A miracle? Perhaps. Whatever the truth of the story, the origins of this ancient sacred place are now lost in the mists of legend.

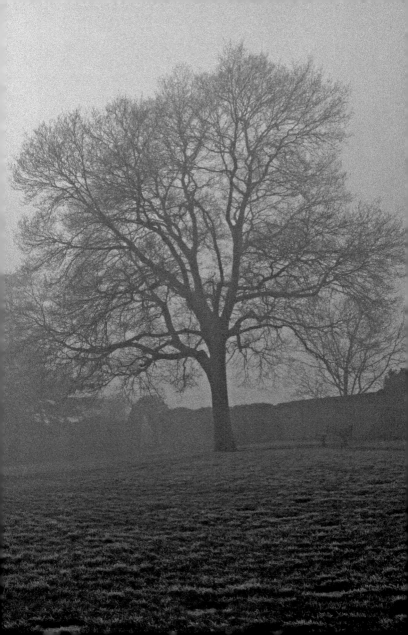

## 2. THE CLOISTER ARCH

The black-cowled Benedictine monks of Evesham Abbey spent their days in prayer and work (*Ora et Labora*). At two each morning they rose for their first liturgical service ('lauds') after which they again retired. At dawn they rose for prayers ('prime'). Three hours later was 'tierce' after which they attended the Chapter House. At noon was the service of 'sexte' after which they dined. At 3 p.m. was 'none'. Sunset saw 'vespers' with, shortly afterwards, a concluding service ('compline') after which they dined and retired.

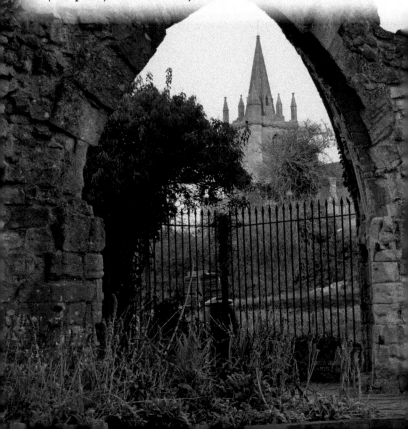

# 3. DEDICATION OF THE SIMON DE MONTFORT MEMORIAL (1965)

Perhaps the most famous person buried at Evesham Abbey, somewhere near the high altar, was Simon de Montfort, Earl of Leicester, slain at the Battle of Evesham (4 August 1265). The battle was brutal: Robert of Gloucester (fl. 1260–1300) described it as 'the murder of Evesham for battle it was none'. The 700th anniversary of the battle was marked by the dedication, by the Archbishop of Canterbury, of a memorial on the approximate site of the high altar. (VEHS)

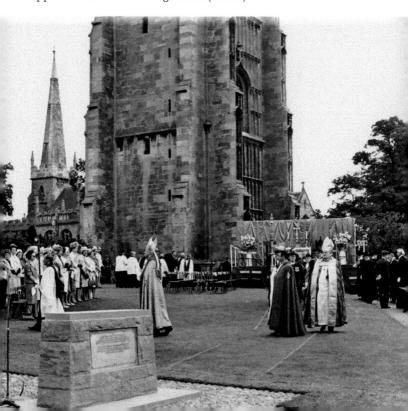

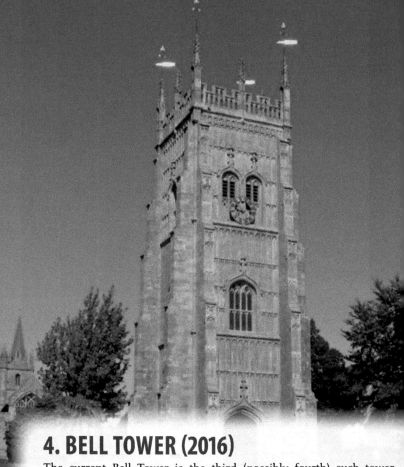

## 4. BELL TOWER (2016)

The current Bell Tower is the third (possibly fourth) such tower to stand on this site. Sometime before 1220 there was a 'great bell tower (campanile) that Adam Sortes began'. In 1319–20, William of Stow, sacrist, may (or may not) have completed a new bell tower (campanarium). A new bell tower was built in the time of Abbot Roger Zatton (1379–1418), which was, presumably, replaced by the bell tower that stands today (built *c.* 1530). (Merry Privett)

# 5. ST LAWRENCE'S CHURCH (C. 1830)

On the morning of the Battle of Evesham (4 August 1265) Simon de Montfort, Earl of Leicester, is believed to have received mass from Walter de Cantilupe, Bishop of Worcester (there was no Abbot of Evesham at the time). Where? Certainly not in the abbey, which had vigorously established its independence from the Bishop of Worcester. So where? Perhaps in St Lawrence's, which was, after all, the town's oldest (and therefore more prestigious) parish church.

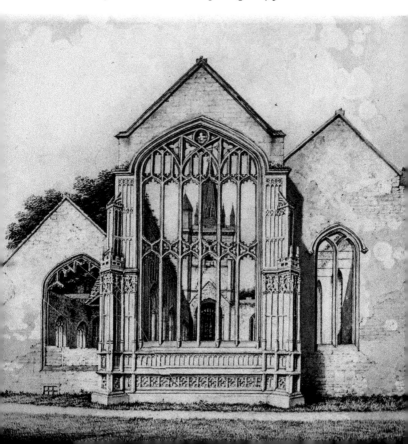

# 6. CHURCHYARD IN SNOW (2014)

The Evesham *Gesta Abbatum* mentions refugees fleeing (*c.* 1070) from the devastation by King William I of northern England ('The Harrying of the North'); they lay about 'in the graveyard here'. Evesham's Anglo-Saxon minster was considered very beautiful, although ancient (*magnum antiquitatis opus*). Abbot Æthelwig (1058–78), the last Anglo-Saxon abbot, collected five caskets of silver for a new church. Abbot Walter (1078–1104), the first Norman abbot, started the task of replacing the old minster with a new Romanesque church.

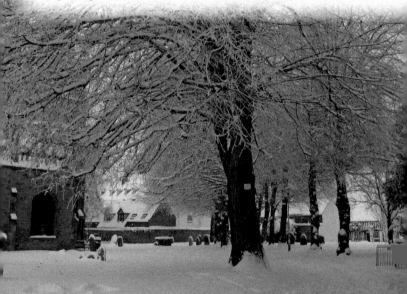

# 7. BATTLE OF EVESHAM BANNERS (2019), INTERIOR OF ST LAWRENCE'S CHURCH

When Simon de Montfort and his army rode out to meet the opposing forces of Prince Edward (later King Edward I) he was heavily outnumbered. He was slain, his army broken, and his fleeing troops ruthlessly pursued. Some escaped into the monastic precinct – into the chapels, cloisters, courtyards, even into the abbey church. They were chased down and killed. St Lawrence's, first mentioned in 1195, was reconsecrated in 1295 after being desecrated during the battle.

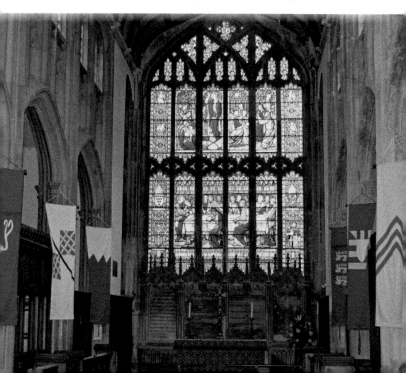

# 8. FAN VAULT CEILING OF LICHFIELD CHAPEL, ST LAWRENCE'S (2019)

Why is St Lawrence considered the earlier church? First, there is an earlier extant reference to St Lawrence's (1195) than All Saints (*c.* 1206). Second, the church stands closer to the site of the abbey church. Third, it is normally mentioned before All Saints in medieval ecclesiastical returns. Fourth, it served the original (Anglo-Saxon) settlement centred on Merstow Green. The most beautiful feature, the southern chantry chapel, was built (*c.* 1520) by Clement Lichfield when prior.

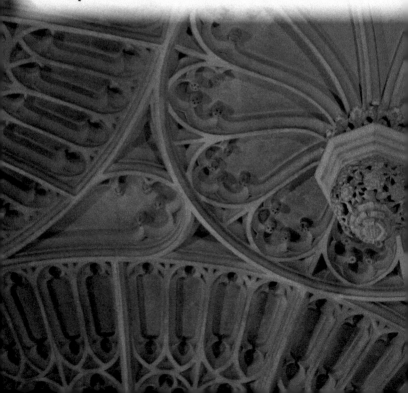

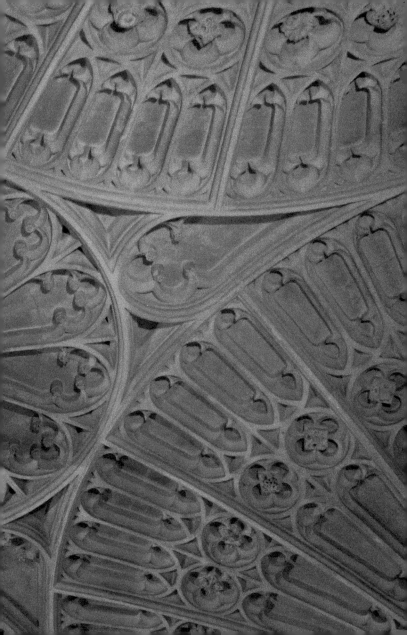

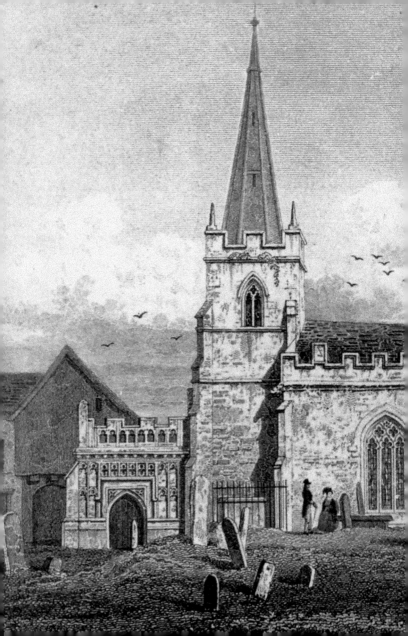

# 9. ALL SAINTS CHURCH

The west porch of All Saints (*Omnium Sanctorum*) was built *c.* 1510 and has two doors: the northern one for townsfolk and the southern one for the abbot and important visitors. In 1820 antiquarian Edward Rudge described the church as: 'Half buried in the earth, small in all its parts, yet with a certain grandeur in the design, it appears to have been built at very distant periods, and many parts of it are composed of heterogeneous fragments.'

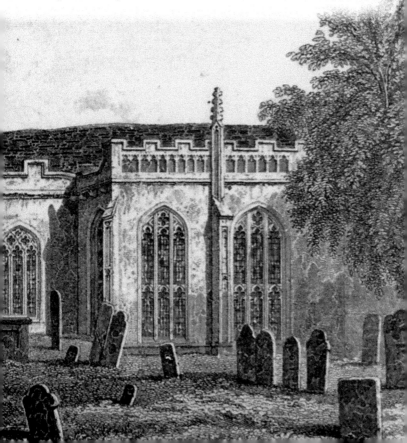

# 10. FAN VAULT CEILING OF THE LICHFIELD CHAPEL, ALL SAINTS

Evesham Abbey was dissolved in January 1540 with, as William Petre wrote to Thomas Cromwell, 'as much quietness as might be desired'. Abbot Clement Lichfield, Evesham's so-called 'last true abbot' (1514–39), died in October 1546 and was buried in the south chantry chapel. He built this chapel *c.* 1510 when he was prior (the pendant above the arch bears the initials CLP), dedicating it to his saintly namesake St Clement.

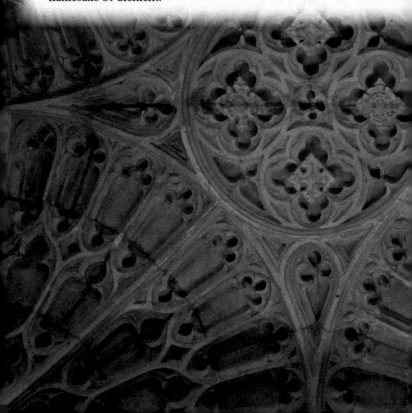

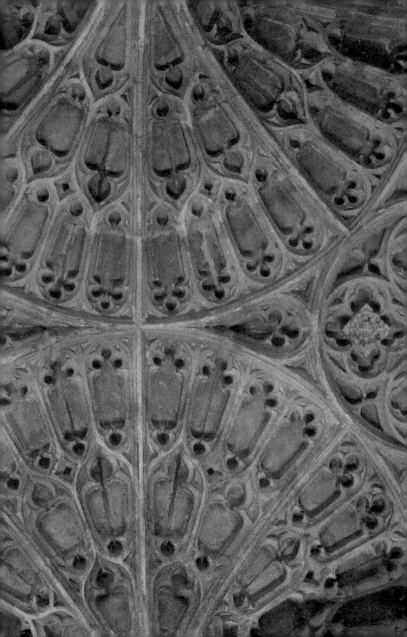

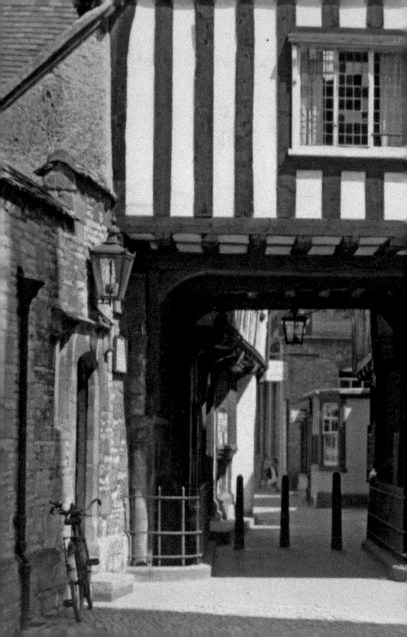

# 11. NORMAN GATEWAY AND CHURCH HOUSE

The gateway, built by Abbot Reginald Foliot (1139–43), was the main entrance to the abbey precinct. A newly elected Abbot of Evesham was received here by his monks before being conducted to the abbey church for formal installation. Church House is a permanent memorial of the 1,200th anniversary of the foundation of the abbey (1909). The room over the gateway, purchased by Mrs Holland in 1863 in memory of her late husband Revd Holland, is called (most appropriately) the Holland Room. (VEHS)

# 12. PLAN OF EVESHAM ABBEY (AFTER RIDSDALE, 1883)

How tall was the abbey tower? Evesham monk John of Alcester, *c.* 1540, wrote that 'The stepull and the towr were xi schore yards in lenth the tower iiijxx and ten and the spyr viixx.' If we accept these numbers, this means the steeple and tower were 11 x 20 = 220 yards high (660 feet). If accurate, that would mean the tip of the abbey spire was three times higher than the top of the Bell Tower (110 feet). An extraordinary sight!

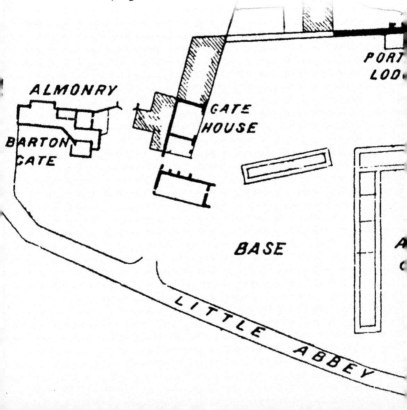

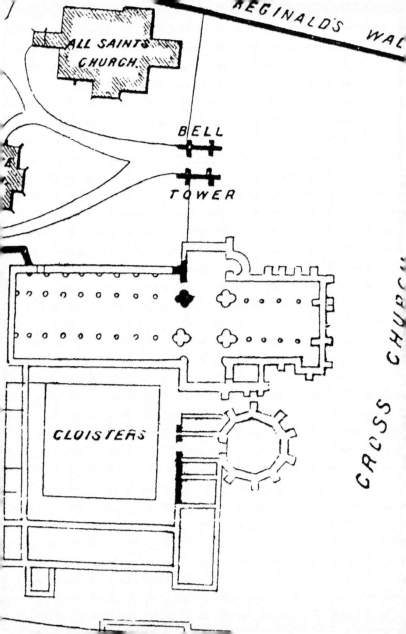

# 13. TWO CHURCHES AND BELL TOWER (C. 1880)

Why two churches? One common explanation is that All Saints served the townsfolk while St Lawrence's was for pilgrims. In reality both were parish churches serving the town. D. C. Cox (1990) wrote 'The building of those churches [c. 1200] ... may have caused the first formal division of the graveyard into secular and monastic portions.' To the east of the Bell Tower (a cemetery gate) was the monks' graveyard; to the west the churchyard of the town. (VEHS)

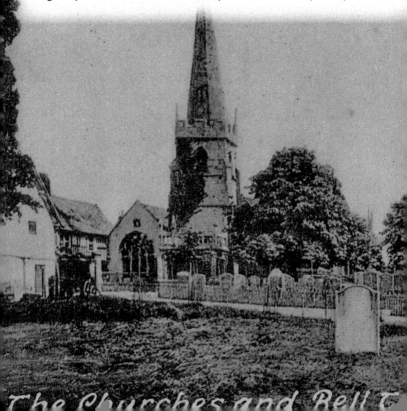

The Churches and Bell T

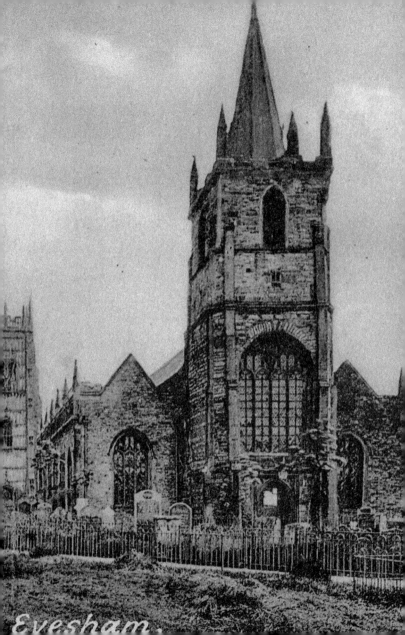

Evesham.

# 14. ABBEY GATES (1950)

Abbot William of 'Chiritone' (1317–44) fortified the abbey with a stone wall with two contiguous gates: the Barton Gate and the Great Abbey Gateway (both had battlements). The latter was built 'opposite the town' (versus villam) suggesting that the town 'proper' was centred on Merstow Green. The Great Gateway was described by Habington (1640) as 'as large and as stately as any at this time in England', being decorated with statues of the Virgin Mary, St Ecgwine, and royal benefactors. It was converted into a house *c.* 1711.

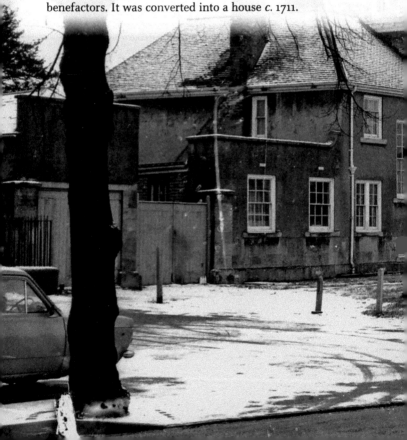

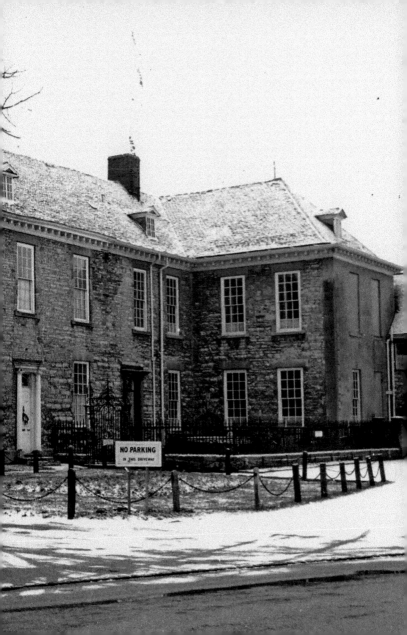

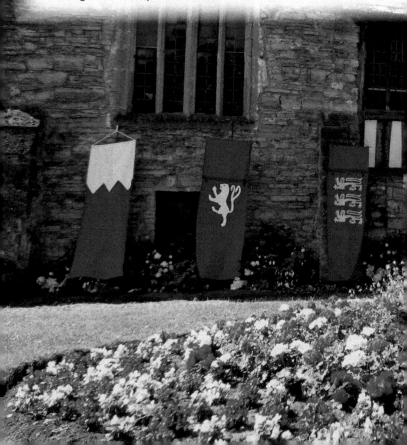

## 15. ALMONRY (2015)

The Almonry (earliest parts *c.* 1320) was home to the abbey almoner, who helped the local poor and sick. Boys who served or sang in the abbey boarded here and were educated at the monastery's expense. At the dissolution (1540) it became a private residence for the abbey's last abbot, Philip Hawford (aka Ballard), who surrendered the abbey to the Crown. To the right of the Almonry stood the Barton Gate leading to the abbey's 'home farm'.

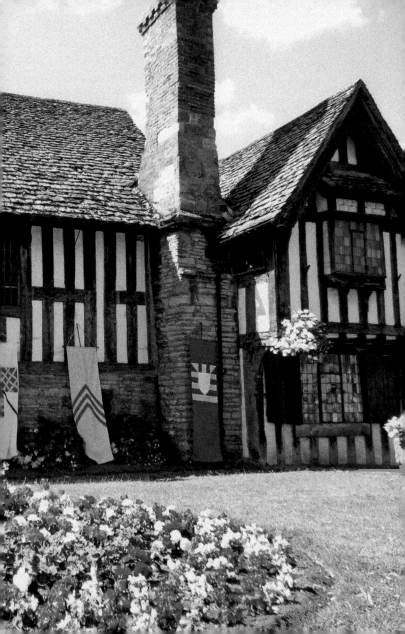

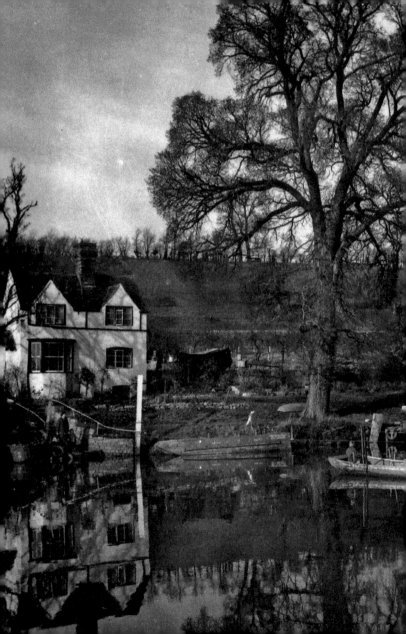

# 16. HAMPTON FERRY (C. 1900)

The Domesday Book (1086) mentions in Hampton 'a young vineyard' (*vinea novella ibi*), thought to be on what is now called Clarke's Hill (the antiquity and origin of which name is uncertain). Around 1210 the officials of the abbey included a 'Warden of the Garden and Vineyard'. Hampton Ferry, one of the oldest rope-pulled ferries in England, links the town within the peninsula to nearby Hampton. Perhaps it originally provided easy access to those vineyards? (VEHS)

# 17. TRUMPET INN (C. 1940)

Evesham was an important pilgrimage site; those who could not stay at the abbey might lodge at an inn. Less religiously minded visitors might stay over in order to attend the weekly market (from *c.* 1206) or one of three annual fairs. Advertising under the right sign could attract the right kind of customer. The sign of the Trumpet is almost certainly religious in origin (an angel's trumpet). Other such local inn signs include Angel Vaults (Port Street) and the Cross Keys (High Street). (VEHS)

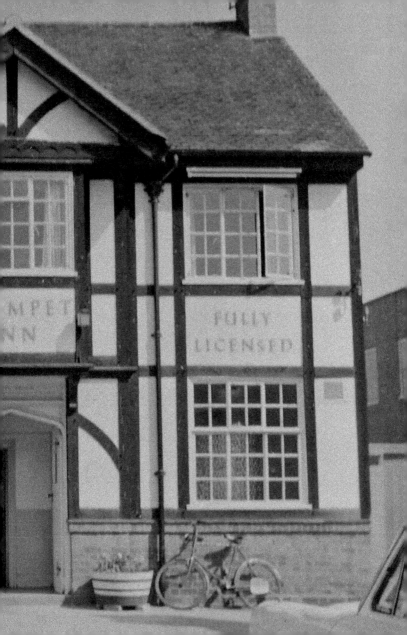

## 18. OLD RED HORSE, VINE STREET (C. 1950)

Before 1840 Vine Street was called 'Pigmarket' from the pig pens erected there on market days. Such markets, and their associated services, were a focal point for the surrounding Vale of Evesham. Indeed, from its earliest days (c. 720) the abbey owned great swathes of local land including Abbots Morton, Aldington, Atch Lench, Badsey, Bengeworth, Bretforton, Chadbury, Church Lench, Childswickham, Church Honeybourne, Fladbury, Hampton, the Littletons, Norton, Offenham, Salford, Sheriffs Lench, Wickhamford and Willersey (plus land further afield). (VEHS)

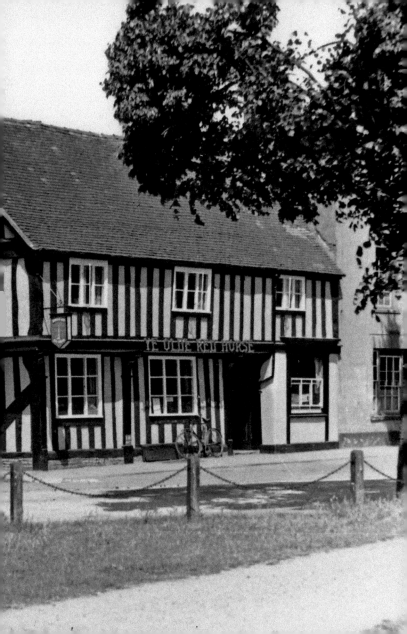

## 19. MAIDEN'S HEAD CORNER, VINE STREET (1909)

The 1,200th anniversary of the consecration of Evesham Abbey was celebrated with a Choral Celebration of Eucharist in All Saints (decorated with white flowers), an address by the Lord Bishop of Bristol, tea for visiting choirs, the formation of a branch of the Mothers' Union, the distribution of over 500 medals, communal suppers, a series of processions, the dedication of a new stained-glass window (Celtic Saints), and the unveiling in All Saints of a memorial brass listing the fifty-five Abbots of Evesham. (VEHS)

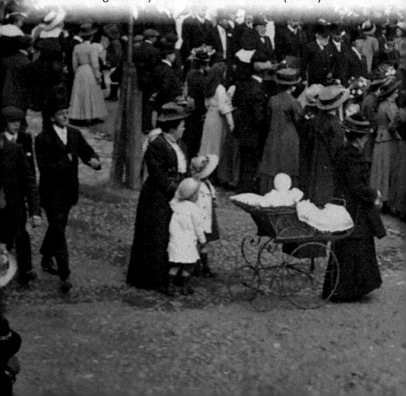

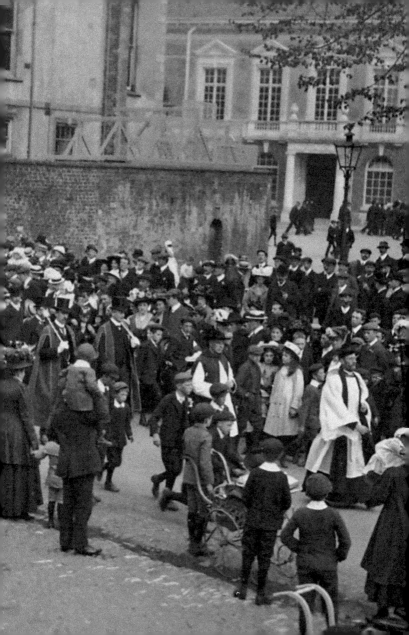

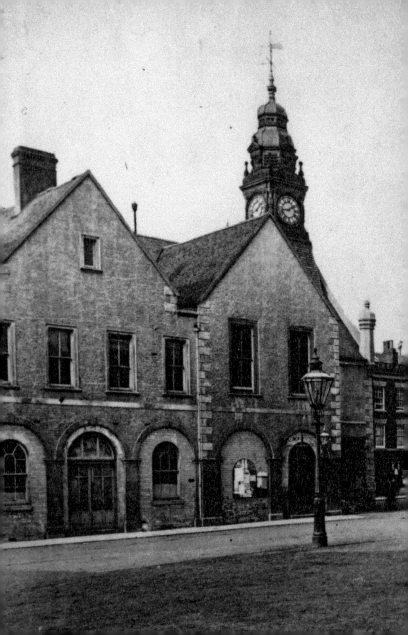

# 20. TOWN HALL (*C.* 1890)

The dissolution of Evesham Abbey (1540) removed the town's feudal lord and created a local power vacuum. Sir Philip Hoby, in 1541/2, purchased the greater portion of the abbey's estates from the Crown. To help establish his local authority he built the Town Hall (*c.* 1580), perhaps with stone from the demolished abbey church, as a gift to the town. The southern section was later (*c.* 1790–1835) the borough gaol and gaoler's residence, with an exercise yard attached. (VEHS)

# 21. PROCLAMATION OF QUEEN ELIZABETH II IN THE MARKET SQUARE (1952)

In centuries past the High Street was a wide-open space extending from the Cross Keys to the parish churchyard, terminating at the wall built by Abbot Reginald Foliot. The area adjacent to Bridge Street and Vine Street was a most attractive commercial area, and was soon encroached upon (including by the Round House). Slowly, but surely, the Market Square was completely enclosed by buildings, creating an excellent venue for public announcements and meetings. (VEHS)

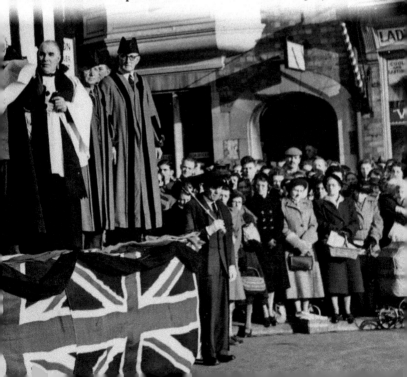

## 22. BRIDGE STREET (C. 1885)

Edmund New (1905): 'Bridge Street is probably the most ancient of the streets. The houses on the south side have gardens reaching to the Abbey walls ... the narrowness of the roadways also goes towards proving its antiquity. This must have been the most frequented thoroughfare, leading as it did in old times to the ford, and afterwards to the bridge and the Abbot's mill beside it. Here were the oldest inns ... the eye still passes with pleasure from house to house, and the effect of the irregularity, heightened by the contrast of light and shade, is picturesque in the extreme.'

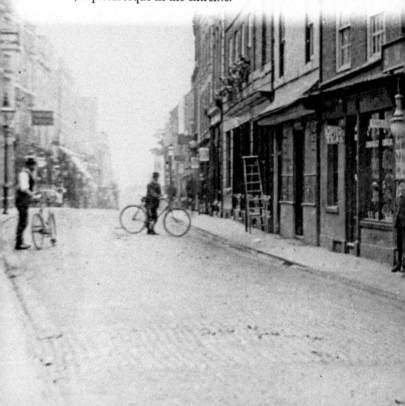

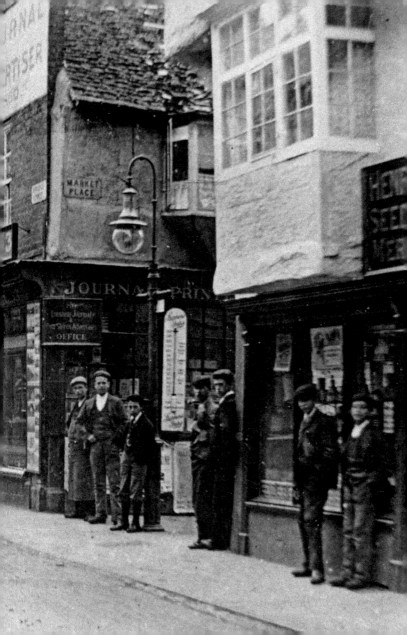

# 23. CATTLE MARKET, HIGH STREET (C. 1910)

Both Vine Street and High Street were built wide to accommodate grain and livestock trading, with narrow entrances to control entry and to facilitate the collection of tolls and taxes. Interestingly, Evesham Abbey traded far and wide, appearing *c.* 1315 in an Italian list of monastic houses supplying wool. Indeed, the Italian designation for Evesham was 'Evesham in the Cotswolds' (*Guesame in Chondisgualdo*). (VEHS)

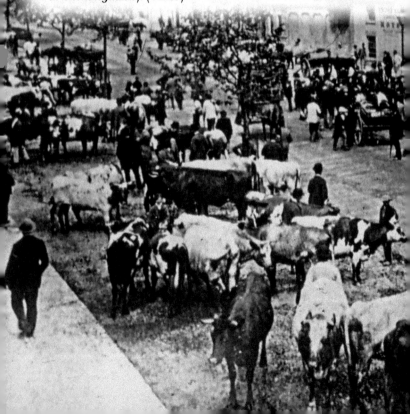

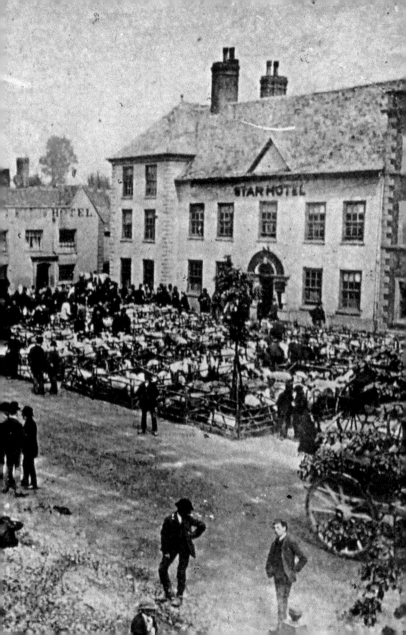

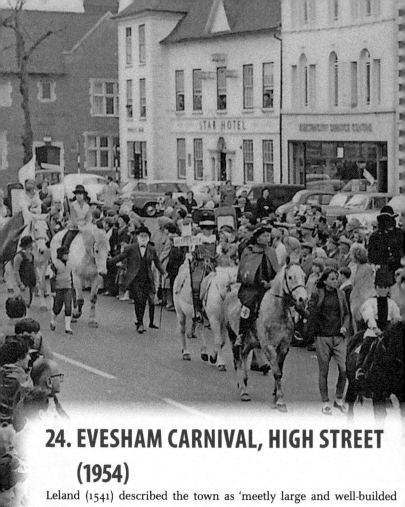

## 24. EVESHAM CARNIVAL, HIGH STREET (1954)

Leland (1541) described the town as 'meetly large and well-builded with timber. The markets are fair and large. There be diverse pretty streets in the town. The market is very celebrate.' The wide High Street would have provided a perfect place for processions by visiting pilgrims. More recently, it's proved ideal for carnivals, pageants and parades. (VEHS)

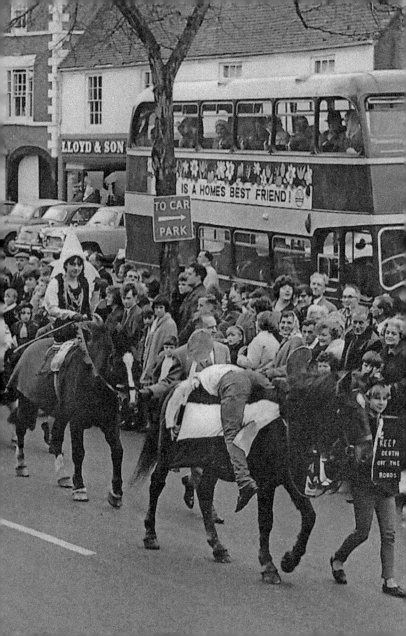

# 25. DRESDEN HOUSE, HIGH STREET (2019)

This brick-built, russet-coloured mansion was built by Robert Cookes in 1692: as stated on an ornate lead spout-head (inset) with the initials 'R.C.' and the family arms. The house acquired its name from Cookes' son-in-law, Dr W. M. Baylies (1724–87), who fled the country to escape creditors, and settled in Dresden. His medical skill prompted Frederick the Great to invite him (1774) to become the royal physician. The gardens once housed a summer house known as 'The Temple' (built *c.* 1750).

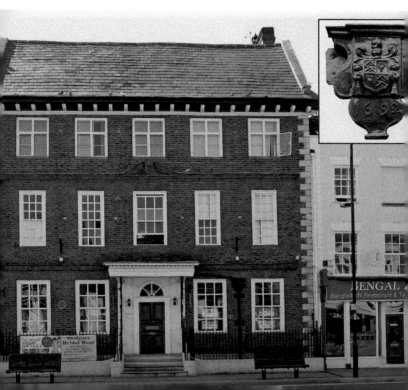

# 26. UNITARIAN CHAPEL, OAT STREET (1845)

After the Civil War (1642–51) religious nonconformity came to town. The Quakers became active in Evesham in 1655. The Baptists arrived *c*. 1670. In 1696 a congregation (no stated denomination) met in a barn in the High Street (at the back of the Black Dog inn); around 1720 they became known as Presbyterians (Protestant Dissenters) and shortly afterwards as Unitarians. The chapel was built in 1737, the schoolrooms in 1759 (enlarged in 1862).

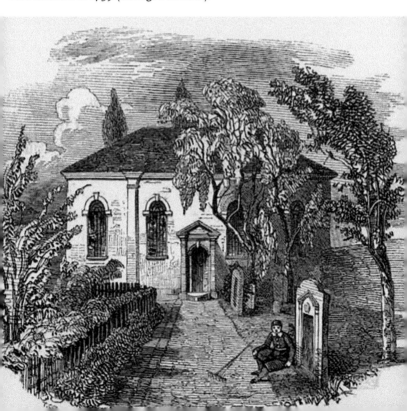

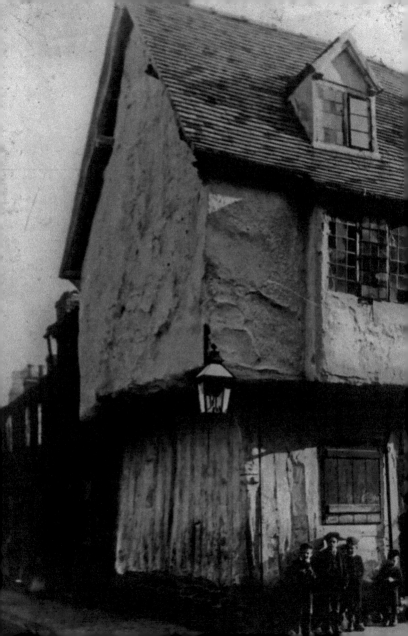

# 27. SHAKESPEARE'S REST, COWL STREET (C. 1890)

There is no established connection between Shakespeare and Evesham; the name of this house is a bit of Victorian entrepreneurial creativity. In his speculative biography of the bard, Charles Knight wrote: 'In the youth of William Shakspere it is impossible that Evesham could have been other than a ruined and desolate place ... Well known is that interesting town to William Shakspere; and he has many traditions connected with its ruined abbey, which have a deep interest even for those who look not upon such matters with the spirit of poetical reverence.' So, did youthful visits inspire Shakespeare?

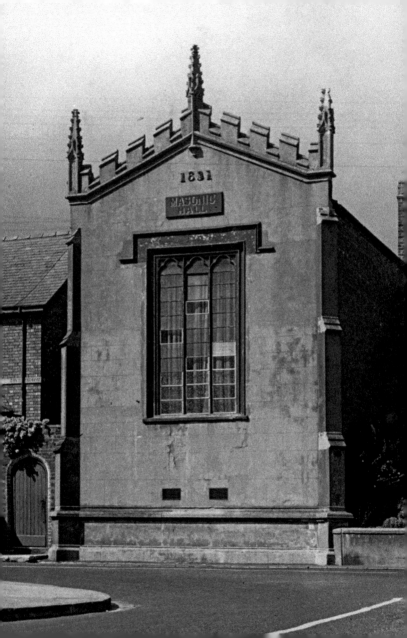

# 28. MASONIC HALL, SWAN LANE (C. 1920)

The Mercy and Truth Lodge No. 703 of freemasons was founded in Evesham in 1818. It met at the Royal Oak (1818), the Rose & Crown (1818–20), the Crown (1820–24), and the Cross Keys (1824–27). Local interest proved thin and there were no meetings in 1829 and only one in 1830. The lodge closed in 1831 and was erased in 1833. Freemasonry returned to Evesham in 1909 with the consecration of **Abbot Lichfield Lodge No. 3308**. The Evesham Masonic Hall Company purchased the hall in 1914. The map below shows this area of Evesham *c.* 1930.

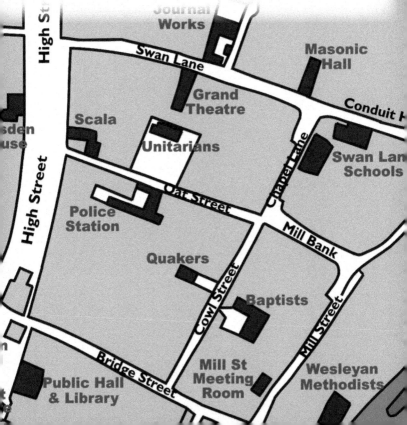

## 29. MILL LANE (2014)

The local importance of river mills is clearly demonstrated in street names: Mill Street, Mill Lane, and Mill Bank (on Mill Hill). The Domesday Book (1086) mentions two mills at Hampton and a mill at Evesham. Abbot Randulf's Institutes (*c.* 1210) records a mill near the bridge, certain other mills at Evesham, a mill at Hampton, and a mill at Twyford. Interestingly, flour dust can be explosive, which is why mills are traditionally built with thick walls and light roofs.

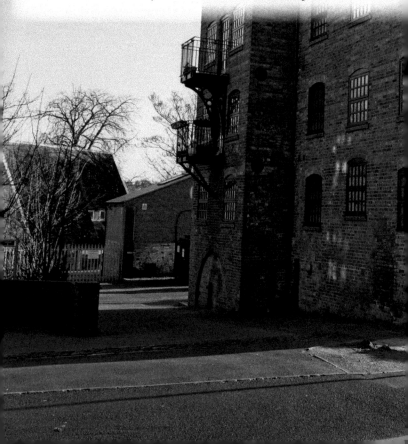

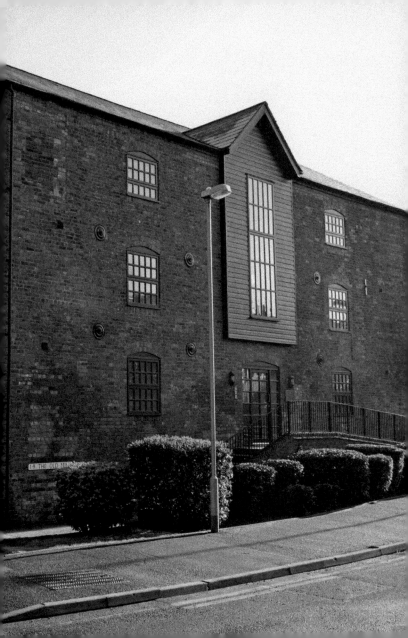

# 30. A-FRAMED LOCK-KEEPERS HOUSE, MILL LANE (*C.* 1980)

Before 1635 the river at Evesham was narrow, sedgy, and blocked with aits (small river islands). In 1635 William Sandys obtained a royal grant to make the river navigable. Work was started, but the Civil War intervened. During the Protectorate (1653–58) William Say completed the work from Tewkesbury to Evesham (Lower Avon Navigation). Shortly after the Restoration (1660) the work from Evesham to Stratford-upon-Avon was completed (Upper Avon Navigation). The lock-keepers house was built in 1972. (VEHS)

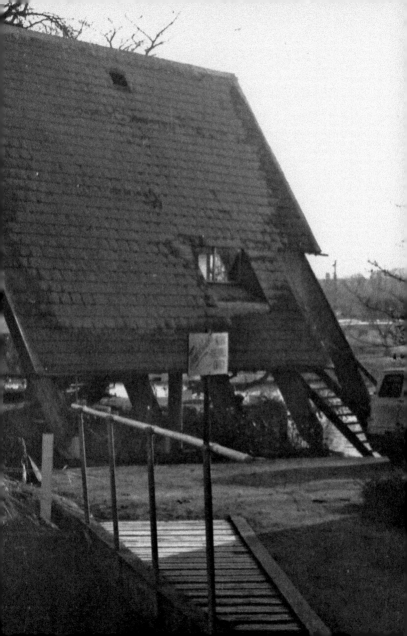

# 31. FLEECE COTTAGES, LOWER BRIDGE STREET (C. 1900)

Bridge Street is sometimes divided into Upper Bridge Street and Lower Bridge Street; the split occurs where the street starts to slope downwards. The lowest part of the street, just before the bridge, used to be called Bridge-foot. There were once a series of yards and wharfs behind and below the Fleece Inn where, it was rumoured, at least in the eighteenth century, smugglers brought in contraband tobacco, rum and lace. Fleece Cottages, sitting below street level, were demolished in 1931. (VEHS)

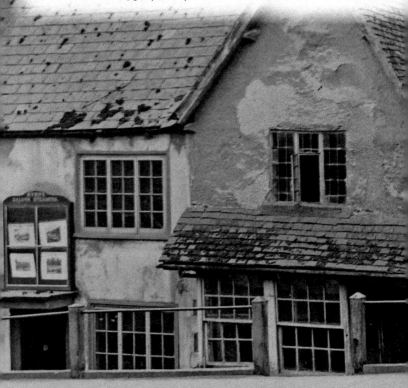

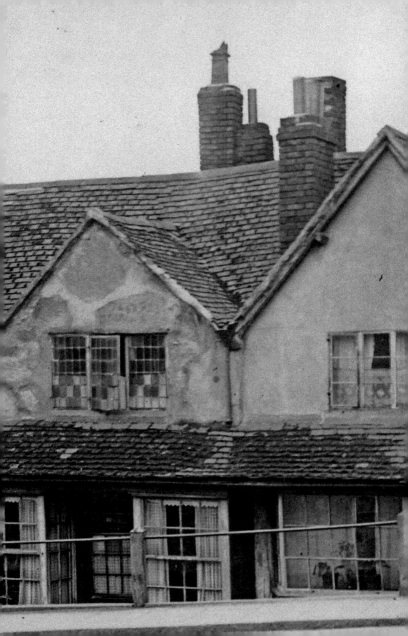

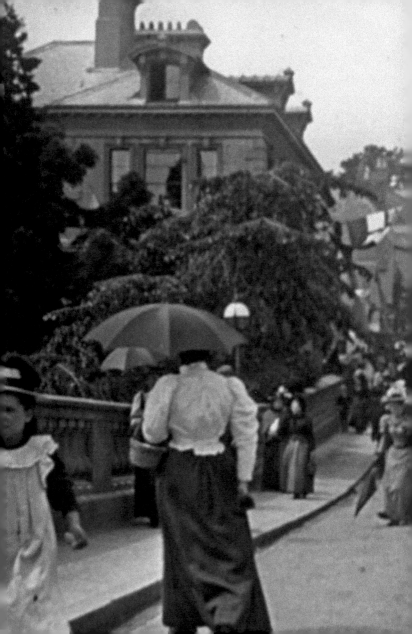

# 32. WORKMAN BRIDGE (C. 1900)

Before a bridge was built (first mentioned *c.* 1155) the main road from Worcester to Oxford passed north of the town at Twyford (Anglo-Saxon for 'two fords'). The old eight-arched medieval bridge was only wide enough for a cart (with walled refuges for pedestrians). It was variously called either the 'Bengeworth Bridge' or the 'Evesham bridge', presumably depending on your direction of travel. Following extensive preparation, the old bridge was replaced in 1856 by the modern three-arched Workman Bridge. (VEHS)

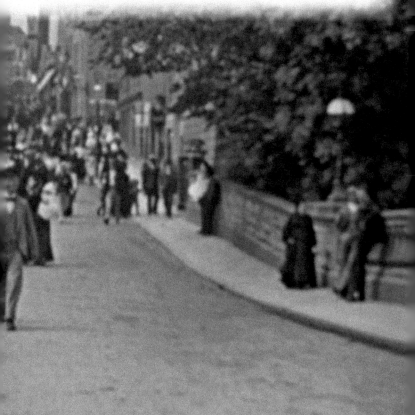

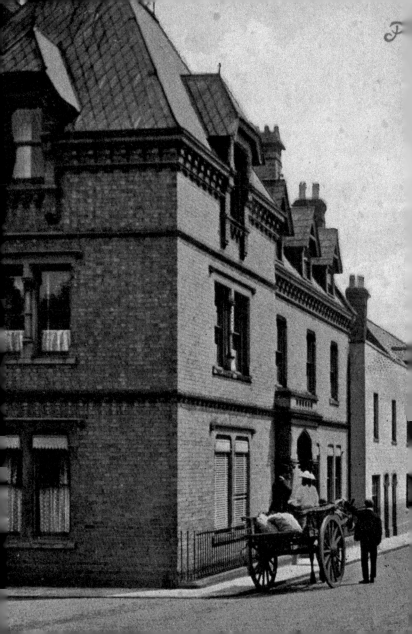

# 33. CORNER OF PORT STREET AND WATERSIDE (C. 1890)

For much of its history Bengeworth consisted of little more than a single street. In 1834 George May wrote in glowing praise of Port Street: 'This street – in the neatness of its houses, the condition of its roads and flagways, together with the refreshing accompaniment of a pellucid stream murmuring on either side – now yields not, in the cheerful cleanliness of its appearance, to any other portion of the town.'

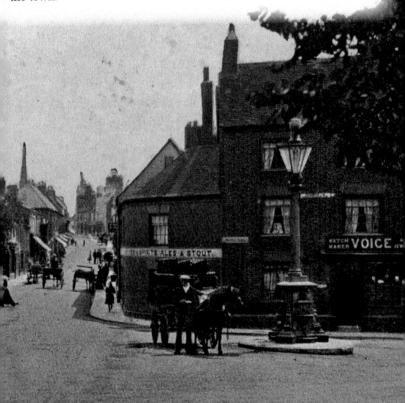

# 34. THE NEW CENTURY FLOOD (1900), PORT STREET

The town suffered a famously severe flood in 1900 when the river rose by over 15 feet. While the river was vital to trade (at least historically) it necessarily brought its own problems. Over the last 200 years there have been other notable floods (with the river rising over 12 feet) including 1848, 1852, 1875, 1882, 1889, 1924, 1932, 1947, 1968, 1998, 2007 and 2012. Clearly there's something of a theme here. (VEHS)

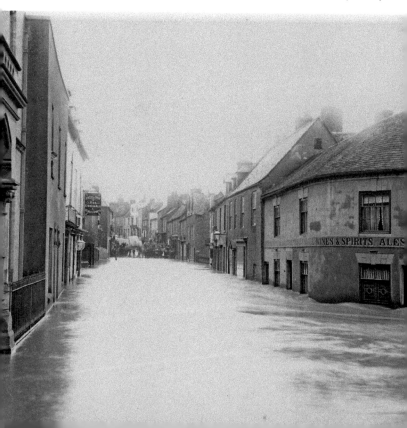

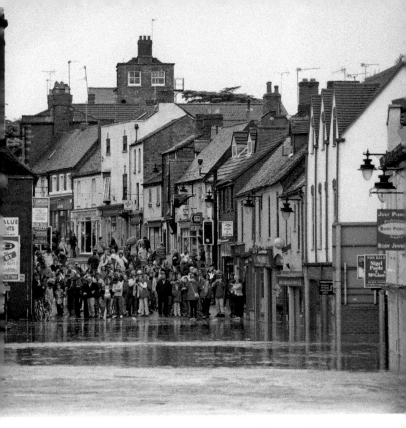

# 35. FLOODS IN PORT STREET (2007)

In 2007 Evesham suffered the most extreme flooding in its history; the river rose over 18 feet. Riverboats were lifted from their moorings, brought downriver and smashed into the Workman Bridge. Narrowboats, firmly attached to poles in the riverbank, sank. The houses along Waterside were flooded – even with their flood defences deployed. Some people were rescued by small boats, while others were airlifted to safety by helicopter.

T.COLSON

# 36. DEACLE SCHOOL (1845)

The Free School, built in 1738, stands a little way back from the street and comprised a house for the master and a schoolroom for the boys. It was provided by the will of John Deacle to teach, clothe and apprentice 'thirty of the poorest boys born in this parish [Bengeworth]'. The will insisted that the schoolmaster apply himself fully to the task, and therefore 'no person in any ecclesiastical orders whatever shall be admitted to fill that situation'.

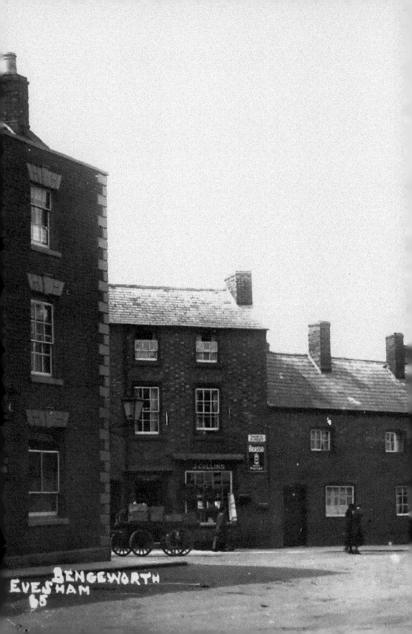

BENGEWORTH
EVESHAM
65

# 37. UPPER PORT STREET (C. 1900)

The Bengeworth observatory (on Port Street) was built by Reginald Victor Craven, inspired by his love of astronomy. His son, Walter Joseph Craven (1915–73), was a chemist, freemason and talented watercolour artist. His business, as manufacturing horticultural chemists, had as its logo a raven holding a letter 'C'. The site of his old works, just off Church Street, is now named 'Craven's Yard' while nearby is 'Craven Court'. (VEHS)

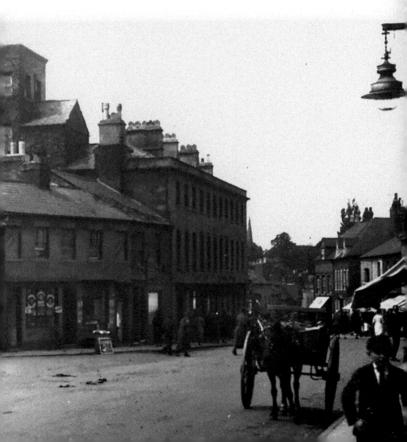

## 38. ST PETER'S CHURCH (C. 1900)

The foundation stone for Bengeworth's new church was laid on 24 October 1871 by Lord Northwick (who provided the land). The Bishop of Worcester consecrated the church on 4 September 1872. The old church (in Church Street) was considered cramped and in dangerous condition (it wasn't). A handful of items from the old church were taken to the new one including the font, holy table and the impressive John Deacle memorial. (VEHS)

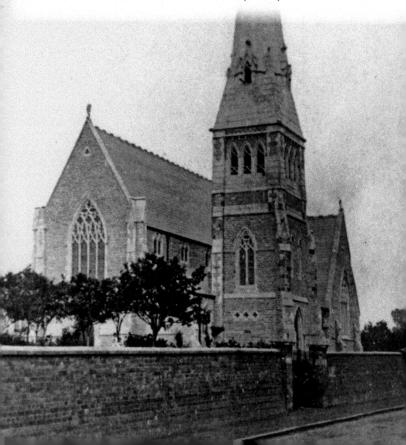

# 39. OLD ST PETER'S CHURCH (C. 1870), ORIGINALLY DEDICATED TO THE HOLY TRINITY

William Tindal (1794) described the church as 'a large, irregular, and plain, but ancient edifice; ornamented with few monuments of note'. It was dynamited once the new church was complete, leading Revd Shawcross (1927) to later lament, 'The demolition of the old parish church was a great misfortune to Bengeworth ... Within one short week the parish was deprived of the outward and standing proof of its antiquity, of its historic past and of the centre of its life and worship.'

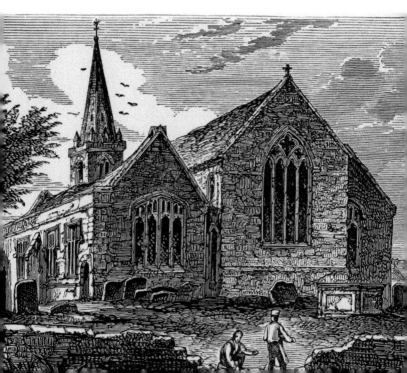

# 40. MANSION HOUSE, COOPERS LANE (2014)

In 1539 Thomas Watson bought 100 acres of land in Bengeworth and built the Mansion House. The lane alongside duly became known as Watson's Lane (a title later reused by a side street). In 1771 the property was rented by Revd Thomas Beale; in 1805 it was taken on by his only surviving nephew, Dr Beale Cooper (who nearly doubled the size of the house). The Mansion House remained a private residence until 1926 when it became a hotel.

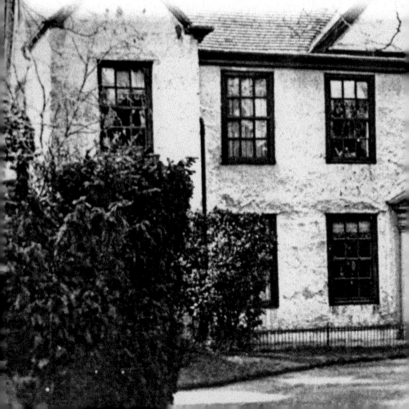

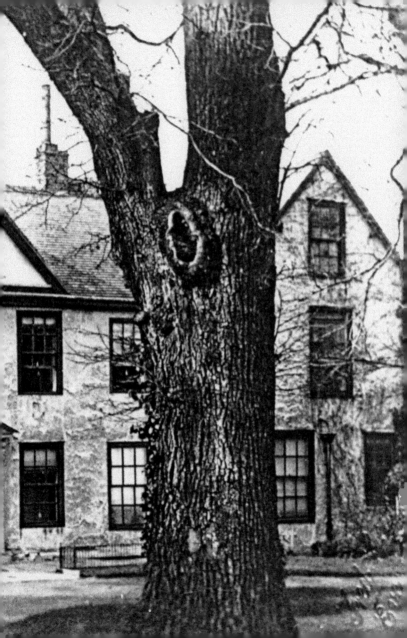

# 41. WORLD FAIR, WORKMAN PLEASURE GARDENS (1912)

Before 1850 the river frontage at Bengeworth was lined with wharves, quays and warehouses. The building of the Workman Bridge (1856) required a radical remodelling, so the entire river frontage was demolished and, in its place, a new 'pleasure garden' was created (an interesting measure of how the Victorian town viewed itself). These gardens became a wonderful venue for shows, fêtes, festivals, fairs, and Sunday afternoon perambulations.

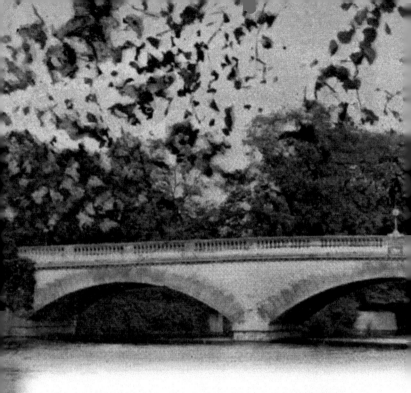

## 42. WORKMAN BRIDGE FROM THE PLEASURE GARDENS (C. 1900)

Edmund New writing in 1905 commented: 'Alas! that modern enterprise and modern requirements should have demanded the removal of such a bridge as fifty years ago [1856] spanned the stream in eight irregular arches. Here we have convenience, but will this condone for the charm of picturesqueness and long association? We cannot but mourn over the loss.' E. A. B. Barnard (1914) considering the now-lost medieval bridge, thought it 'handsome ... one of the most interesting structures in connection with the borough'. (VEHS)

Bridge, Evesh

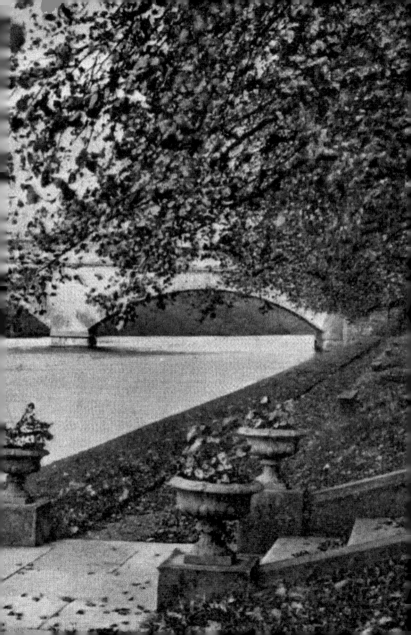

# 43. GAMES ON THE RIVER, EVESHAM HOSPITAL GALA (1928)

Fun and fundraising often go hand in hand. In the interwar period (1918–39) the town's cottage hospital (built in 1879 in Briar Close) enjoyed widespread local support. In part, perhaps, this resulted from an annual parade and gala to raise much-needed funds. On Avonside the Evesham Union workhouse (built in 1837) was taken over, in 1939, by Avonside Hospital. Between 1940 and 1946 it was managed by the RAF to treat injured airmen. This has now become Evesham Community Hospital. (VEHS)

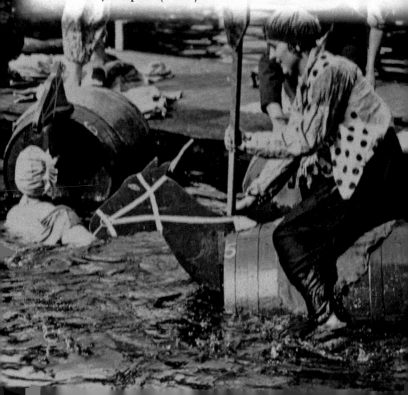

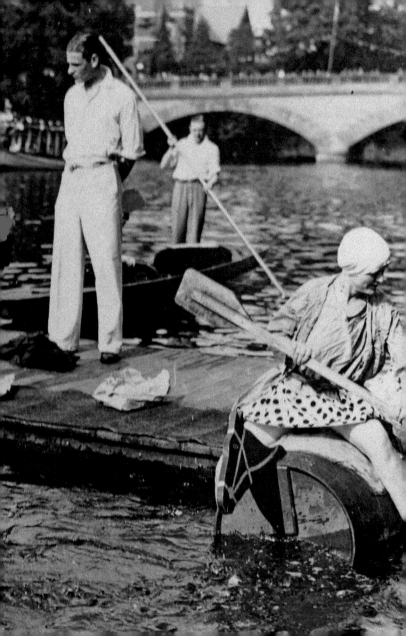

## 44. RIVERSIDE (1990)

In the 1750s a raised causeway – later known as Avonside – was built to connect Waterside with the Hampton Turnpike (at the bottom of the Cheltenham Road). This required building a bridge over the Battleton Brook. In Anglo-Saxon charters this tributary was called the 'Pederedan' (a Celtic place name of uncertain meaning), which name later became `River Parret' and, then, later, somehow, `the Battleton Brook'. The watercourse marks the boundary between Bengeworth and Little Hampton, and the point where Waterside ended and Avonside began. (VEHS)

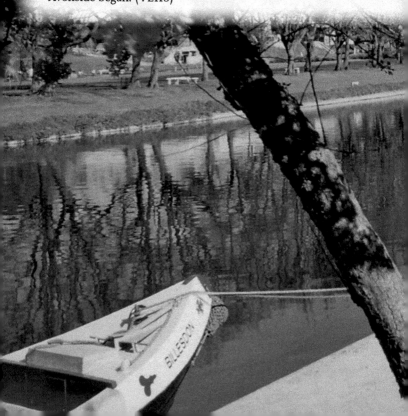

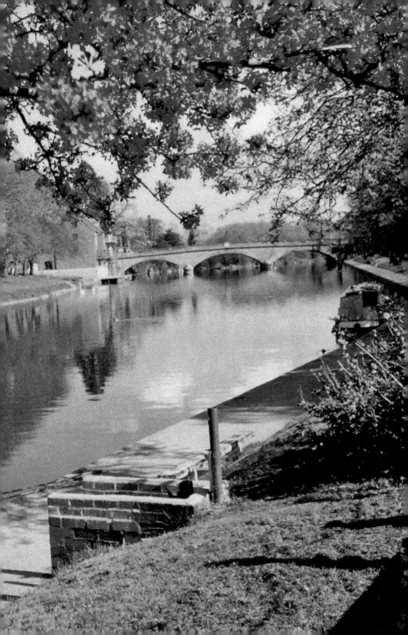

# 45. REGATTA, EVESHAM ROWING CLUB (1936)

Evesham Rowing Club was formed in 1863 'to pursue the manly and innocent recreation of rowing'. The club's initial home was a timber boathouse leased from 'The Fleece'. In 1892/3 it moved into a purpose-built brick clubhouse on its present location (extended 1908 and 2005/6). The club's main event is its annual regatta, first held in 1864, which is now an impressive two-day event held at the end of April (or early May). (VEHS)

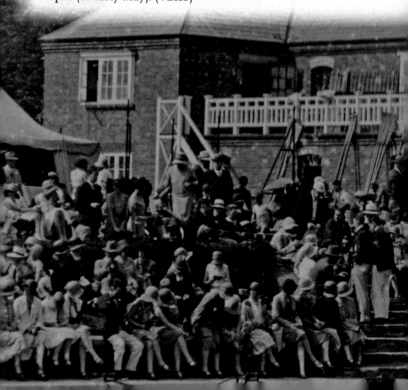

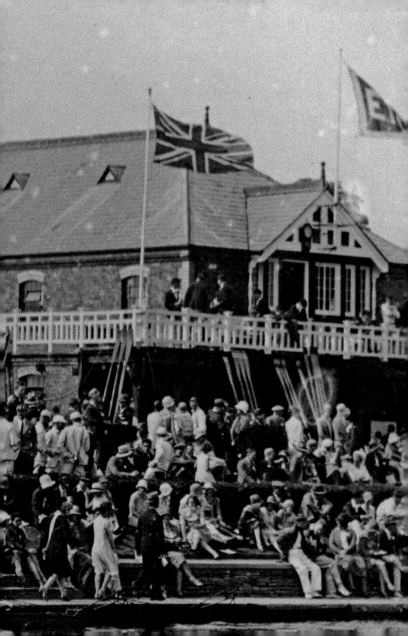

# 46. WATERSIDE CEMETERY, AVONSIDE (2015)

The parish churchyard in the centre of town was closed for burials in 1855, as was the old Bengeworth churchyard. A site for a new graveyard was selected at the edge of Bengeworth (Avonside), opening in 1875. The mortuary chapel on the left is Church of England; that on the right for nonconformists. They are now used by Evesham Town Council as outside staff offices and storage. Incidentally, the churchyard of St Andrew's (Hampton) was closed in 2000.

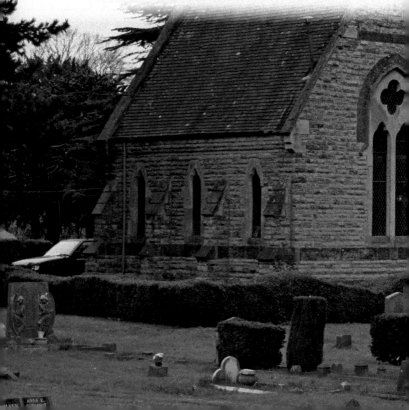

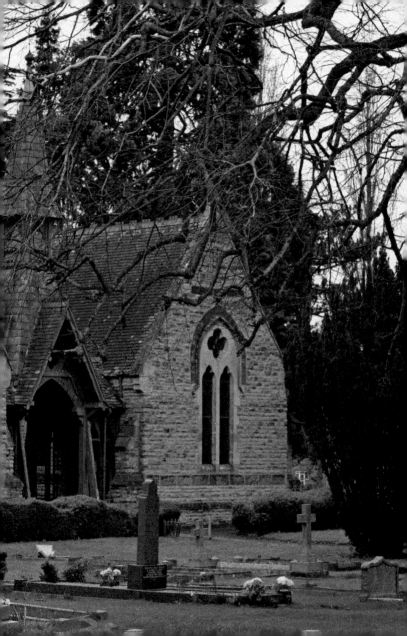

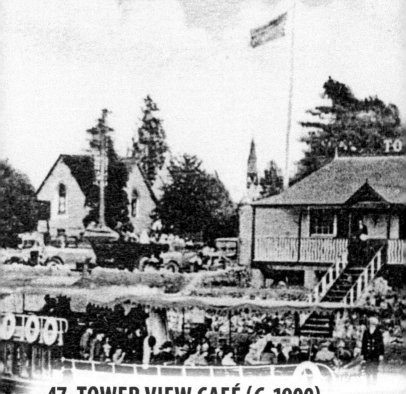

## 47. TOWER VIEW CAFÉ (C. 1900)

The river has increasingly become important for tourism. The arrival of the railways (1852 and 1864) started to bring in day-trippers. Among the town's many attractions was the river. By 1900 passenger steamers were making regular trips from Evesham to Tewkesbury. Visitors could also hire punts and rowing boats. Later there were pleasure craft and holiday narrowboats. This café, now long gone, was a perfect place to relax and admire all that river activity. (VEHS)

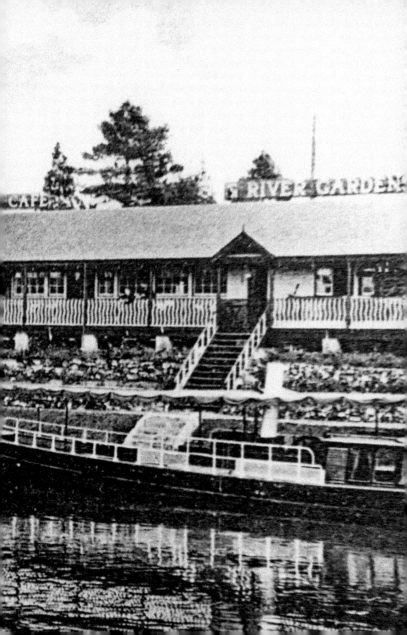

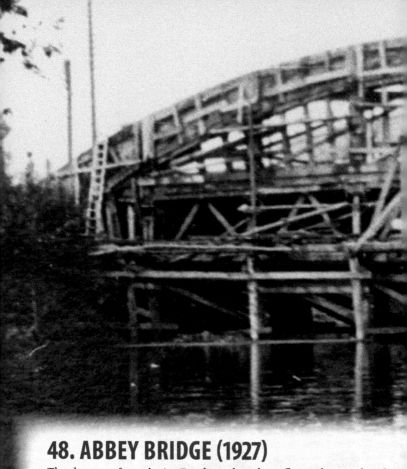

# 48. ABBEY BRIDGE (1927)

The layout of roads in Evesham largely reflects the needs of a medieval town. In the twentieth century there was significantly increased road traffic. What to do? To help ease the situation, in 1928, a viaduct (Abbey Road) was built to connect to a newly constructed steel and ferro-concrete Abbey Bridge. The damaging floods of 2012 required the replacement of the bridge in 2014. (VEHS)

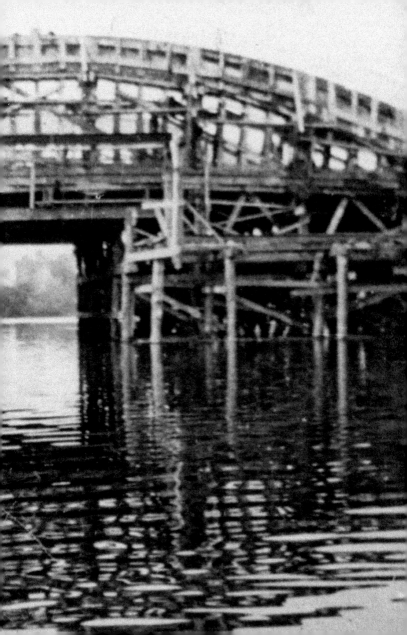

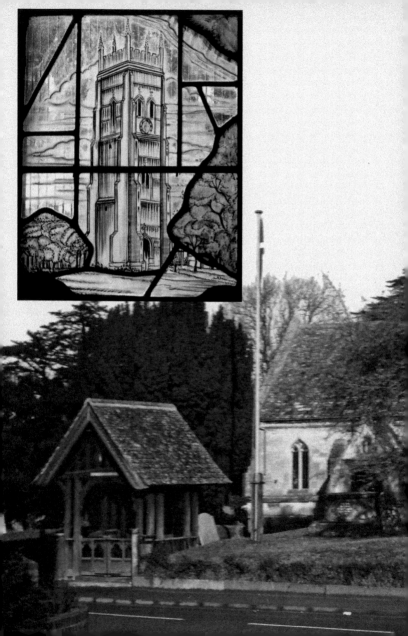

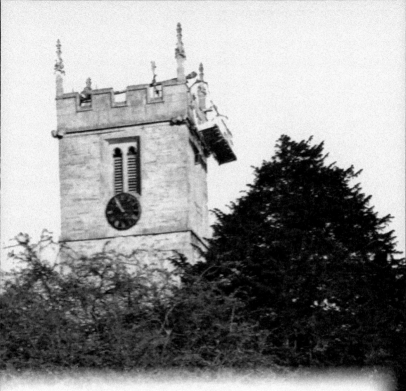

# 49. ST ANDREW'S CHURCH

Crossing the bridge over the River Isbourne takes you from Little Hampton into Great Hampton. On older maps (with a Latin leaning) you might sometimes see them labelled as 'Hampton Parva' and 'Hampton Magna'. For many centuries Hampton was a neighbouring village, but in 1933 the parish of Great and Little Hampton was incorporated into the borough. This church, dating from the 1100s but largely rebuilt *c.* 1400, stands as a substantial reminder of Hampton's long history. Incidentally, the riverside walk from Hampton Ferry to the River Isbourne was once known (*c.* 1900) as Lover's Walk. (VEHS)

# 50. ABBEY ROAD

Walking back to the town centre, across the Abbey Bridge, takes you past meadows and gardens. In the days of the abbey this area was the 'home farm' of Evesham Abbey. Later it was used as open agricultural land (sometimes for oxen and sheep). Later still, some of the land became intensively worked market gardens. The Crown Meadow is now set aside for fêtes, fairs, festivals and public recreation. It is truly remarkable that, at the heart of this picturesque town, there remains this wonderful open green space.

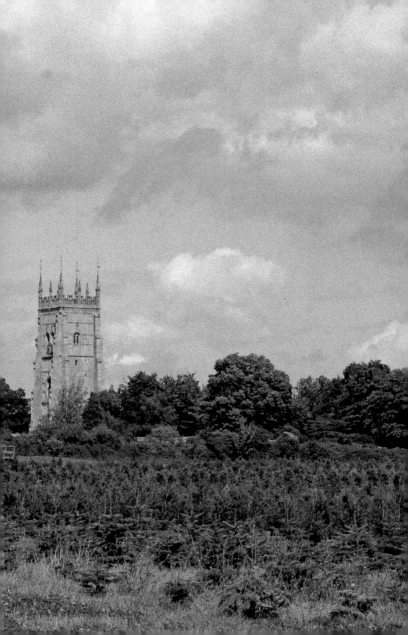

# SELECTED BIBLIOGRAPHY

Cox, D. C. (1990), 'The Building, Destruction, and Excavation of Evesham Abbey: a Documentary History', Transactions of the Worcestershire Archaeological Society, 3rd series, 12.

Knight, Charles (1865), William Shakspere: A Biography (New York: George Routledge & Sons).

Rudge, E. J. (1820), A Short Account of the History and Antiquities of Evesham (Evesham: A. Agg).

May, George (1845), A Descriptive History of the Town of Evesham (Evesham: George May).

Shawcross, J. P. (1927), Bengeworth (Evesham: The Journal Press).

Tindal, William (1794), The History and Antiquities of Evesham (Evesham: John Agg).